Dreams of Love
Rossetti Poetry

Introduced by Amy Key

Introduced by
Amy Key

Dreams of Love

Rossetti Poetry

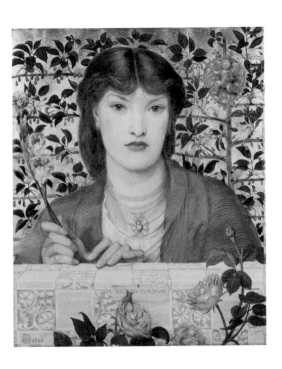

Introduction
by Amy Key

In a sepia photograph taken when I was fourteen or so, my hair is swept back from my face. My throat and jawline are exposed, drawing the viewer into the image. These features have become the centre, a point of balance and light. When I first saw the photograph I hated it – the strength of that jawline, my inelegant neck, jutting chin. But I look now and see something else. I see Elizabeth Siddal, painted by Dante Gabriel Rossetti, in his painting *Regina Cordium* 1860, which I had a postcard print of. It's not that I look anything like her – I don't possess a 'genius' beauty like that of Siddal or Jane Morris, another of Rossetti's muses. But it was this image I wanted to replicate when I asked my friend to take my photograph. I thought the way I'd posed would make me beautiful.

Some of the earliest artworks I engaged with were created by the Pre-Raphaelite Brotherhood. In my friendship group, at least, there seemed to come a moment when each of us imagined ourselves Ophelia, dressed in our ornate robes, in our river-baths, surrounded by the lavish marginal plants. We were white girls in the north of England, rookie teenagers. We desired either being milk pale or to have the illusion of 'a tan', with the twin desires those complexions suggested: tragedy and sex. We wanted to merge our lives 'in a dream of love!'[1]

We took most of the sepia photos in a grave-yard. In the shots, we are leaning mournfully against tombs and gravestones wreathed with ivy and lichen. Our hair is long, and we are clothed in crushed velvet with a Pre-Raphaelite colour palette. With one friend I swapped an exercise book back and forth. In biro I'd written 'The Book' on the front and in it we wrote things we felt were words and statements of objective truth, beauty and meaning. We were teenaged which meant we knew everything and trusted no one. Rejected what we believed to be fake, vapid, futile. Paradoxically, we were at the same time deeply engaged with our own mythology, determined to find a way to be significant in the world, work out how to make it all worth it and attain a state of being special. At one point, when I complained of not being as thin and polished as my contemporaries, of feeling out of fashion with the aesthetic ideals of my time, an adult described me as 'a Pre-Raphaelite beauty'. Very briefly, I felt powerfully fluent with being admired.

The poems arising from the Pre-Raphaelite era did not make the same early impression on me. I found their rhythms and rhymes lacked the voluptuous, inviting intensity of the artworks. Even with my own melodramatic tendencies, I was put off by the foreboding tone of the poems; they felt and sounded stricken. This left little room for my own feelings to contribute to and develop the meaning,

as though I had no worthy interpretation to bring forth. Where the paintings were illuminated with potent feeling, the same feeling in the poems felt dominated to the point of weakness by the grandeur of the register. My reluctance to engage with the poems is by no means unique: in the introduction to Penguin's anthology of Pre-Raphaelite poetry, Dinah Roe writes that the poems have a reputation as 'a "fleshly", self-indulgent trend'[2], with a fetish for pretentious expression.

But then I found a poem by Christina Rossetti, 'Introspective'. Sometimes it only takes a line, or a couple of lines, to launch a poem deep into your understanding of the world, into your emotional vocabulary. In this poem it was 'Dumb I was when the ruin fell, / Dumb I remain and will never tell'.[3] I had my own secrets, you see, and the repetition, rhythm and rhyme of these two lines adhered to me, became my own expression of what I could not tell. It is with this in mind I have approached collecting the poems of Dante Gabriel Rossetti, Christina Rossetti and Elizabeth Siddal: a curiosity as to what I might have missed the first time I encountered their works.

What I discovered is that while I am not a convert to the favoured formal constraints of these three poets, I have found in their work some deep resonances with the concerns of our time – money, love, beauty, shame, death. I have found myself excited by the ways in which the Rossettis had such

rich creative practices – all three were artist, writer, thinker, muse. They recognised the power of image to deepen engagement with text and vice versa, the result a near cinematic experience for the reader, allowing complete immersion in the writer-artist's imagination. This expansive, ambitious way of engaging with the world, their commitment to collaboration and comradeship as the ways in which they could make their points, is one I am inspired by, even if I can feel its limits, and reject how gendered the Pre-Raphaelite movement was. They may have invited Christina Rossetti to join them (she declined), but I can't help think they saw women 'Not as she is, but as she fills his dream.'[4] On this point the presentation of Elizabeth Siddal's poems on equal footing with Dante Gabriel Rossetti's poems feels important. Siddal's poems expose her unease and mistrust of being valued as muse above all other qualities and talents. Her poems reclaim her subjectivity, a refusal of being mere object, and this view is complemented by Christina Rossetti's observations on the objectification of women in art.

Reading Siddal's poems now, I am forced to ask why I idealised her image as painted by men, and why she remains such an enduring muse, her tragedy exceeding interest in her artistry. As I researched Siddal, I discovered that a poet I admire, Gillian Allnutt, had written a poem in Siddal's voice, ventriloquising her. Allnutt imagines Siddal preoccupied by the fear she will become

'shorn' of Dante Gabriel Rossetti's 'wild desire'.[5] The loss of his gaze will fade her identity because she has come to rely on his eyes – the mirror of his vision of her – to be in touch with who she is. This is not just conjecture on Allnutt's part; the speaker of Siddal's own poem 'The Lust of the Eyes', whom we can assume is her lover, smiles to think how his 'love will fleet' when her 'starlike beauty dies'.[6] The knowledge that love is conditional on her beauty is, that love is 'seldom true',[7] is a threat that must be borne, and Siddal's poetry documents – in some cases with cool sarcasm – her bitterness about it. Unlike Shakespeare's Ophelia, Siddal attempts to resist the idea of being 'incapable of her own distress'.

Of the three Rossettis collected here, it is the work of Dante Gabriel Rossetti that I am most conflicted about. Perhaps it is because his poems in particular feel overlong and overwrought. Or, because as a male writer who has been afforded more prestige than his even his much celebrated sister Christina – and certainly more than his eternally captivating wife, muse and model Elizabeth – I feel obliged to relegate him in the order of my attentions. In one of his most famous poems, the dramatic monologue 'Jenny', the speaker is the male client of a sex worker. He characterises Jenny through her beauty – her likeness lilies and roses, symbols of purity and love – and takes an obsessive interest in her internal world: 'what a book

you seem, / Half-read by lightning in a dream!'[8] The poem valorises Jenny, but it valorises the speaker too – how compassionate he is to love someone society rejects! As a modern reader, the thing that most interests me about this poem (if I can put to one side that this poem was in the manuscript Dante Gabriel Rossetti exhumed from the grave of his wife Elizabeth Siddal some seven years after her burial) is the way the speaker can't make up his mind about who is most deserving of shame, Jenny or the speaker himself, who seems to congratulate himself for his inquisitiveness about and care for the sleeping Jenny. It is infuriatingly patronising. As I am not a scholar, I cannot say whether it spoke to or was a radical interjection in its age or not, but I can recommend looking up a more recent pastiche by the writer Daniel M. Lavery that, to my reading, got the measure of the poem: 'Imagine, someone describing you the way they do when they're praying. / Wild stuff. But I'm open-minded like that.'[9]

Christina Rossetti – today the most respected of the Pre-Raphaelite poets – is for me the most satisfying to read. Her long poem 'Goblin Market', described by poet Carol Rumens as a 'lavishly sensuous masterpiece', invites multi-layered interpretations. A tale of two sisters, a tale of temptation, gluttony, resistance and struggle, it is deeply textured in its rich imagery, gregarious listing of fruits, spell-like repetition, rhymes that

resist the constraint of a pattern. Its language and form model the excess the poem describes – 'She sucked and sucked and sucked the more'.[10] If I can't quite endorse Christina Rossetti's rejection of mortal and material pleasures, I can certainly endorse the triumph of sisterly love and care. I ask why, in this precarious present when access to some pleasures will become threadbare, we can't take our joys in both 🍂

1 Elizabeth Siddal, 'The Passing of Love', in Dinah Roe (ed.), *The Pre-Raphaelites: From Rossetti to Ruskin*, London 2010, p.143.

2 Roe 2010, p.xvii.

3 Christina Rossetti, 'Introspective', in C. H. Sisson (ed), *Selected Poems*, Carcanet 2002.

4 Christina Rossetti, 'In an Artist's Studio', in Roe 2010, p.182.

5 Gillian Allnut, from 'Lizzie Siddal: Her Journal [1862]', *Beginning the Avocado*, Virago 1987, pp.37-43

6 Elizabeth Siddal, 'The Lust of the Eyes', in Roe 2010, p.139.

7 Elizabeth Siddal, 'Dead Love', in Roe 2010, p.136.

8 D.G. Rossetti, 'Jenny', in Roe 2010, p.94.

9 Daniel M. Lavery, 'Dante Gabriel Rossetti's "Jenny"', *The Toast*, 7 March 2016, https://the-toast.net/2016/03/07/dante-gabriel-rossettis-jenny (accessed 16 Nov. 2022).

10 Christina Rossetti, 'Goblin Market', in Roe 2010, pp.155-71.

Poems

Elizabeth Siddal

Christina Rossetti

Dante Gabriel Rossetti

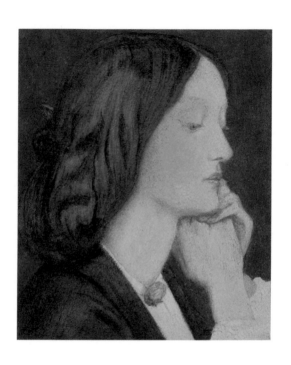

Elizabeth Siddal

Lord, May I Come?

Life and night are falling from me,
Death and day are opening on me.
Wherever my footsteps come and go
Life is a stony way of woe.
 Lord, have I long to go?
Hollow hearts are ever near me,
Soulless eyes have ceased to cheer me:
 Lord, may I come to Thee?
Life and youth and summer weather
To my heart no joy can gather:
Lord, lift me from life's stony way.
Loved eyes, long closed in death, watch o'er me –
Holy Death is waiting for me –
 Lord, may I come to-day?
My outward life feels sad and still,
Like lilies in a frozen rill.

I am gazing upwards to the sun,
Lord, Lord, remembering my lost one.
 O Lord, remember me!
How is it in the unknown land?
Do the dead wander hand in hand?
Do we clasp dead hands, and quiver
With an endless joy for ever?
Is the air filled with the sound
Of spirits circling round and round?
Are there lakes, of endless song,
To rest our tirèd eyes upon?
Do tall white angels gaze and wend
Along the banks where lilies bend?
Lord, we know not how this may be;
Good Lord, we put our faith in Thee-
 O God, remember me.

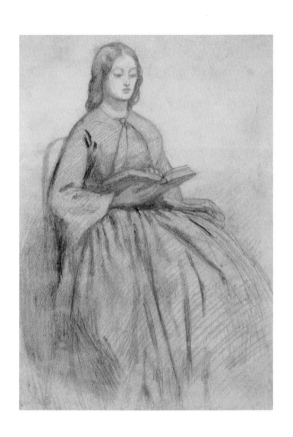

Love and Hate

Ope not thy lips, thou foolish one,
 Nor turn to me thy face:
The blasts of heaven shall strike me down
 Ere I will give thee grace.

Take thou thy shadow from my path,
 Nor turn to me and pray:
The wild, wild winds thy dirge may sing
 Ere I will bid thee stay.

Lift up they false brow from the dust,
 Nor wild thine hands entwine
Among the golden summer-leaves
 To mock the gay sunshine.

And turn away thy false dark eyes,
 Nor gaze into my face:
Great love I bore thee; now great hate
 Sits grimly in its place.

All changes pass me like a dream,
 I neither sing nor pray;
And thou art like the poisonous tree
 That stole my life away.

At Last

O mother, open the window wide
 And let the daylight in;
The hills grow darker to my sight,
 And thoughts begin to swim.

And mother dear, take my young son,
 (Since I was born of thee),
And care for all his little ways,
 And nurse him on thy knee.

And, mother, wash my pale, pale hands,
 And then bind up my feet;
My body may no longer rest
 Out of its winding-sheet.

And, mother dear, take a sapling twig
 And green grass newly mown,
And lay them on my empty bed,
 That my sorrow be not known.

And, mother, find three berries red
 And pluck them from the stalk,
And burn them at the first cockcrow,
 That my spirit may not walk.

And mother dear, break a willow wand,
 And if the sap be even,
Then save it for my lover's sake
 And he'll know my soul's in heaven.

And, mother, when the big tears fall
 (And fall, God knows, they may),
Tell him I died of my great love,
 And my dying heart was gay.

And, mother dear, when the sun has set,
 And the pale church grass waves,
Then carry me through the dim twilight
 And hide me among the graves.

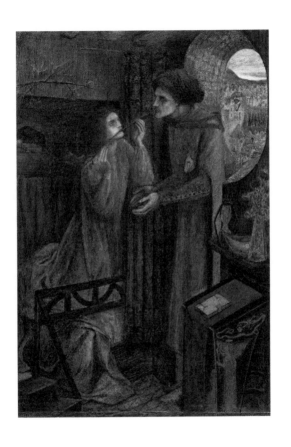

Dead Love

Oh never weep for love that's dead,
 Since love is seldom true,
But changes his fashion from blue to red,
 From brightest red to blue,
And love was born to an early death
 And is so seldom true.
Then harbour no smile on your loving face
 To win the deepest sigh;
The fairest words on truest lips
 Pass on and surely die;
And you will stand alone, my dear,
 When wintry winds draw nigh.

Sweet, never weep for what cannot be,
 For this God has not given:
If the merest dream of love were true,
 Then, sweet, we should be in heaven;
And this is only earth, my dear,
 Where true love is not given.

The Passing of Love

O God, forgive me that I merged
 My life into a dream of love!
Will tears of anguish never wash
 The poison from my blood?

Love kept my heart in a song of joy,
 My pulses quivered to the tune;
The coldest blasts of winter blew
 Upon me like sweet airs in June.

Love floated on the mists of morn,
 And rested on the sunset's rays;
He calmed the thunder of the storm,
 And lighted all my ways.

Love held me joyful through the day,
 And dreaming ever through the night:
No evil thing could come to me,
 My spirit was so light.

O Heaven help my foolish heart
 Which heeded not the passing time
That dragged my idol from its place
 And shattered all its shrine!

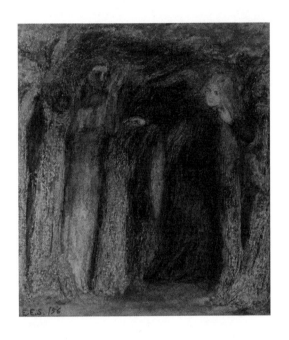

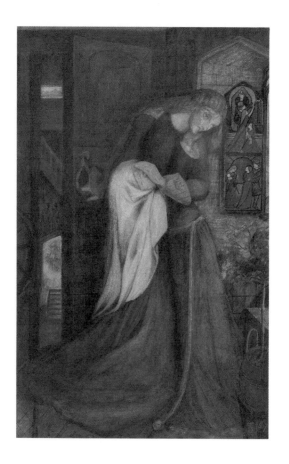

The Lust of The Eyes

I care not for my Lady's soul,
 Though I worship before her smile:
I care not where be my Lady's goal
 When her beauty shall lose its wile.

Low sit I down at my Lady's feet,
 Gazing through her wild eyes,
Smiling to think how my love will fleet
 When their starlike beauty dies.

I care not if my Lady pray
 To our Father which is in Heaven;
But for joy my heart's quick pulses play,
 For to me her love is given.

Then who shall close my Lady's eyes,
 And who shall fold her hands?
Will any hearken if she cries
 Up to the unknown lands?

A Year and a Day

Slow days have passed that make a year,
 Slow hours that make a day,
Since I could take my first dear love
 And kiss him the old way;
Yet the green leaves touch me on the cheek,
 Dear Christ, this month of May.

I lie among the tall green grass
 That bends above my head
And covers up my wasted face,
 And folds me in its bed
Tenderly and lovingly
 Like grass above the dead.

Dim phantoms of an unknown ill
 Float through my tired brain;
The unformed visions of my life
 Pass by in ghostly train;
Some pause to touch me on the cheek,
 Some scatter tears like rain.

A shadow falls along the grass
 And lingers at my feet;
A new face lies between my hands –
 Dear Christ, if I could weep
Tears to shut out the summer leaves
 When this new face I greet.

Still it is but the memory
 Of something I have seen
In the dreamy summer weather
 When the green leaves came between:
The shadow of my dear love's face –
 So far and strange it seems.

The river ever running down
 Between its grassy bed,
The voices of a thousand birds
 That clang above my head,
Shall bring to me a sadder dream
 When this sad dream is dead.

A silence falls upon my heart
 And hushes all its pain.
I stretch my hands in the long grass
 And fall to sleep again,
There to lie empty of all love
 Like beaten corn of grain.

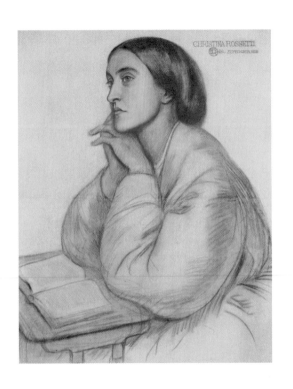

Christina Rossetti

A Birthday

My heart is like a singing bird
 Whose nest is in a watered shoot;
My heart is like an apple tree
 Whose boughs are bent with thickset fruit;
My heart is like a rainbow shell
 That paddles in a halcyon sea;
My heart is gladder than all these
 Because my love is come to me.

Raise me a dais of silk and down;
 Hang it with vair and purple dyes;
Carve it in doves and pomegranates,
 And peacocks with a hundred eyes;
Work it in gold and silver grapes,
 In leaves and silver fleurs-de-lys;
Because the birthday of my life
 Is come, my love is come to me.

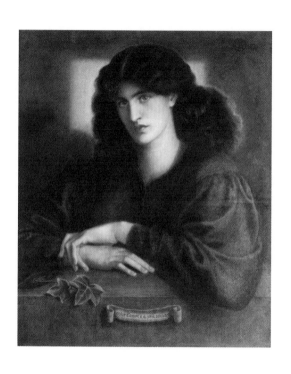

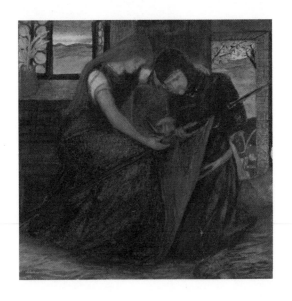

A Pause of Thought

I looked for that which is not, nor can be,
 And hope deferred made my heart sick in truth:
 But years must pass before a hope of youth
 Is resigned utterly.

I watched and waited with a steadfast will:
 And though the object seemed to flee away
 That I so longed for, ever day by day
 I watched and waited still.

Sometimes I said: This thing shall be no more;
 My expectation wearies and shall cease;
 I will resign it now and be at peace:
 Yet never gave it o'er.

Sometimes I said: It is an empty name
 I long for; to a name why should I give
 The peace of all the days I have to live? –
 Yet gave it all the same.

Alas, thou foolish one! alike unfit
 For healthy joy and salutary pain:
 Thou knowest the chase useless, and again
 Turnest to follow it.

Sweet Death

The sweetest blossoms die.
 And so it was that, going day by day
 Unto the Church to praise and pray,
And crossing the green churchyard thoughtfully,
 I saw how on the graves the flowers
 Shed their fresh leaves in showers,
And how their perfume rose up to the sky
 Before it passed away.

The youngest blossoms die.
 They die and fall and nourish the rich earth
 From which they lately had their birth;
Sweet life, but sweeter death that passeth by
 And is as though it had not been: -
 All colours turn to green;
The bright hues vanish and the odours fly,
 The grass hath lasting worth.

And youth and beauty die.
 So be it, O my God, Thou God of truth:
 Better than beauty and than youth
Are Saints and Angels, a glad company;
 And Thou, O Lord, our Rest and Ease,
 Are better far than these.
Why should we shrink from our full harvest? why
 Prefer to glean with Ruth?

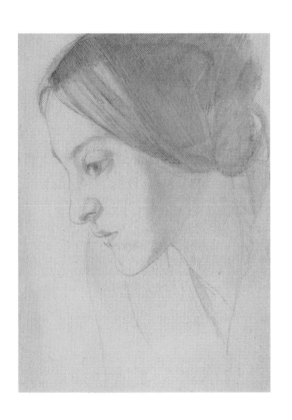

In an Artist's Studio

One face looks out from all his canvasses,
 One selfsame figure sits or walks or leans;
 We found her hidden just behind those screens,
That mirror gave back all her loveliness.
A queen in opal or in ruby dress,
 A nameless girl in freshest summer greens,
 A saint, an angel; — every canvass means
The same one meaning, neither more or less.
He feeds upon her face by day and night,
 And she with true kind eyes looks back on him
Fair as the moon and joyful as the light:
 Not wan with waiting, not with sorrow dim;
Not as she is, but was when hope shone bright;
 Not as she is, but as she fills his dream.

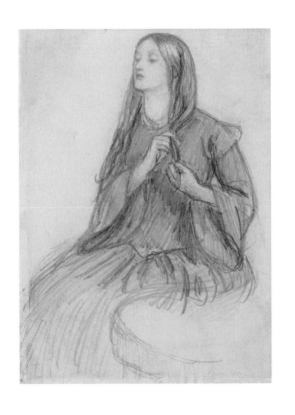

Introspective

I wish it were over the terrible pain,
Pang after pang again and again;
First the shattering ruining blow,
Then the probing steady and slow.

Did I wince? I did not faint:
My soul broke but was not bent;
Up I stand like a blasted tree
By the shore of the shivering sea.

On my boughs neither leaf nor fruit,
No sap in my uttermost root,
Brooding in an anguish dumb
On the short past and the long to come.

Dumb I was when the ruin fell,
Dumb I remain and will never tell:
O my soul I talk with thee
But not another the sight must see.

I did not start when the torture stung,
I did not faint when the torture wrung;
Let it come tenfold if come it must
But I will not groan when I bite the dust.

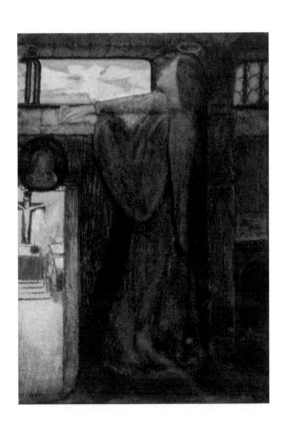

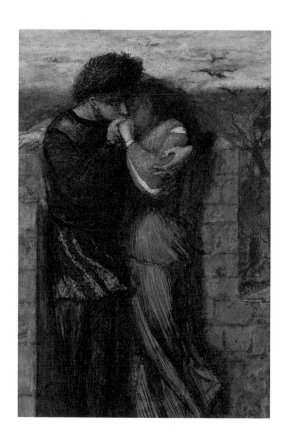

42

An End

Love, strong as Death, is dead.
Come, let us make his bed
Among the dying flowers:
A green turf at his head;
And a stone at his feet,
Whereon we may sit
In the quiet evening hours.

He was born in the Spring,
And died before the harvesting:
On the last warm Summer day
He left us; he would not stay
For Autumn twilight cold and gray.
Sit we by his grave, and sing
He is gone away.

To few chords and sad and low
Sing we so:
Be our eyes fixed on the grass
Shadow-veiled as the years pass
While we think of all that was
In the long ago.

Goblin Market

Morning and evening
Maids heard the goblins cry:
"Come buy our orchard fruits,
Come buy, come buy:
Apples and quinces,
Lemons and oranges,
Plump unpecked cherries,
Melons and raspberries,
Bloom-down-cheeked peaches,
Swart-headed mulberries,
Wild free-born cranberries,
Crab-apples, dewberries,
Pine-apples, blackberries,
Apricots, strawberries; –
All ripe together
In summer weather, –
Morns that pass by,
Fair eves that fly;
Come buy, come buy:
Our grapes fresh from the vine,
Pomegranates full and fine,
Dates and sharp bullaces,
Rare pears and greengages,
Damsons and bilberries,
Taste them and try:
Currants and gooseberries,
Bright-fire-like barberries,
Figs to fill your mouth,

Citrons from the South,
Sweet to tongue and sound to eye;
Come buy, come buy."

Evening by evening
Among the brookside rushes,
Laura bowed her head to hear,
Lizzie veiled her blushes:
Crouching close together
In the cooling weather,
With clasping arms and cautioning lips,
With tingling cheeks and finger tips.
"Lie close," Laura said,
Pricking up her golden head:
"We must not look at goblin men,
We must not buy their fruits:
Who knows upon what soil they fed
Their hungry thirsty roots?"
"Come buy," call the goblins
Hobbling down the glen.
"Oh," cried Lizzie, "Laura, Laura,
You should not peep at goblin men."
Lizzie covered up her eyes,
Covered close lest they should look;
Laura reared her glossy head,
And whispered like the restless brook:
"Look, Lizzie, look, Lizzie,
Down the glen tramp little men.
One hauls a basket,
One bears a plate,

One lugs a golden dish
Of many pounds weight.
How fair the vine must grow
Whose grapes are so luscious;
How warm the wind must blow
Thro' those fruit bushes."
"No," said Lizzie, "No, no, no;
Their offers should not charm us,
Their evil gifts would harm us."
She thrust a dimpled finger
In each ear, shut eyes and ran:
Curious Laura chose to linger
Wondering at each merchant man.
One had a cat's face,
One whisked a tail,
One tramped at a rat's pace,
One crawled like a snail,
One like a wombat prowled obtuse and furry,
One like a ratel tumbled hurry skurry.
She heard a voice like voice of doves
Cooing all together:
They sounded kind and full of loves
In the pleasant weather.

Laura stretched her gleaming neck
Like a rush-imbedded swan,
Like a lily from the beck,
Like a moonlit poplar branch,
Like a vessel at the launch
When its last restraint is gone.

Backwards up the mossy glen
Turned and trooped the goblin men,
With their shrill repeated cry,
"Come buy, come buy."
When they reached where Laura was
They stood stock still upon the moss,
Leering at each other,
Brother with queer brother;
Signalling each other,
Brother with sly brother.
One set his basket down,
One reared his plate;
One began to weave a crown
Of tendrils, leaves, and rough nuts brown
(Men sell not such in any town);
One heaved the golden weight
Of dish and fruit to offer her:
"Come buy, come buy," was still their cry.
Laura stared but did not stir,
Longed but had no money:
The whisk-tailed merchant bade her taste
In tones as smooth as honey,
The cat-faced purr'd,
The rat-paced spoke a word
Of welcome, and the snail-paced even was heard;
One parrot-voiced and jolly
Cried "Pretty Goblin" still for "Pretty Polly;" –
One whistled like a bird.

But sweet-tooth Laura spoke in haste:
"Good folk, I have no coin;
To take were to purloin:
I have no copper in my purse,
I have no silver either,
And all my gold is on the furze
That shakes in windy weather
Above the rusty heather."
"You have much gold upon your head,"
They answered all together:
"Buy from us with a golden curl."
She clipped a precious golden lock,
She dropped a tear more rare than pearl,
Then sucked their fruit globes fair or red:
Sweeter than honey from the rock,
Stronger than man-rejoicing wine,
Clearer than water flowed that juice;
She never tasted such before,
How should it cloy with length of use?
She sucked and sucked and sucked the more
Fruits which that unknown orchard bore;
She sucked until her lips were sore;
Then flung the emptied rinds away
But gathered up one kernel-stone,
And knew not was it night or day
As she turned home alone.

Lizzie met her at the gate
Full of wise upbraidings:
"Dear, you should not stay so late,

Twilight is not good for maidens;
Should not loiter in the glen
In the haunts of goblin men.
Do you not remember Jeanie,
How she met them in the moonlight,
Took their gifts both choice and many,
Ate their fruits and wore their flowers
Plucked from bowers
Where summer ripens at all hours?
But ever in the noonlight
She pined and pined away;
Sought them by night and day,
Found them no more but dwindled and grew grey;
Then fell with the first snow,
While to this day no grass will grow
Where she lies low:
I planted daisies there a year ago
That never blow.
You should not loiter so."
"Nay, hush," said Laura:
"Nay, hush, my sister:
I ate and ate my fill,
Yet my mouth waters still;
Tomorrow night I will
Buy more:" and kissed her:
"Have done with sorrow;
I'll bring you plums tomorrow
Fresh on their mother twigs,
Cherries worth getting;
You cannot think what figs

My teeth have met in,
What melons icy-cold
Piled on a dish of gold
Too huge for me to hold,
What peaches with a velvet nap,
Pellucid grapes without one seed:
Odorous indeed must be the mead
Whereon they grow, and pure the wave they drink
With lilies at the brink,
And sugar-sweet their sap."

Golden head by golden head,
Like two pigeons in one nest
Folded in each other's wings,
They lay down in their curtained bed:
Like two blossoms on one stem,
Like two flakes of new-fall'n snow,
Like two wands of ivory
Tipped with gold for awful kings.
Moon and stars gazed in at them,
Wind sang to them lullaby,
Lumbering owls forbore to fly,
Not a bat flapped to and fro
Round their rest:
Cheek to cheek and breast to breast
Lock'd together in one nest.

Early in the morning
When the first cock crowed his warning,
Neat like bees, as sweet and busy,

Laura rose with Lizzie:
Fetched in honey, milked the cows,
Aired and set to rights the house,
Kneaded cakes of whitest wheat,
Cakes for dainty mouths to eat,
Next churned butter, whipped up cream,
Fed their poultry, sat and sewed;
Talked as modest maidens should:
Lizzie with an open heart,
Laura in an absent dream,
One content, one sick in part;
One warbling for the mere bright day's delight,
One longing for the night.

At length slow evening came:
They went with pitchers to the reedy brook;
Lizzie most placid in her look,
Laura most like a leaping flame.
They drew the gurgling water from its deep;
Lizzie plucked purple and rich golden flags,
Then turning homeward said: "The sunset flushes
Those furthest loftiest crags;
Come, Laura, not another maiden lags.
No wilful squirrel wags,
The beasts and birds are fast asleep."
But Laura loitered still among the rushes
And said the bank was steep.

And said the hour was early still
The dew not fall'n, the wind not chill:
Listening ever, but not catching
The customary cry,
"Come buy, come buy,"
With its iterated jingle
Of sugar-baited words:
Not for all her watching
Once discerning even one goblin
Racing, whisking, tumbling, hobbling;
Let alone the herds
That used to tramp along the glen,
In groups or single,
Of brisk fruit-merchant men.

Till Lizzie urged, "O Laura, come;
I hear the fruit-call but I dare not look:
You should not loiter longer at this brook:
Come with me home.
The stars rise, the moon bends her arc,
Each glowworm winks her spark,
Let us get home before the night grows dark:
For clouds may gather
Tho' this is summer weather,
Put out the lights and drench us thro';
Then if we lost our way what should we do?"

Laura turned cold as stone
To find her sister heard that cry alone,
That goblin cry,

"Come buy our fruits, come buy."
Must she then buy no more such dainty fruit?
Must she no more such succous pasture find,
Gone deaf and blind?
Her tree of life drooped from the root:
She said not one word in her heart's sore ache;
But peering thro' the dimness, nought discerning,
Trudged home, her pitcher dripping all the way;
So crept to bed, and lay
Silent till Lizzie slept;
Then sat up in a passionate yearning,
And gnashed her teeth for baulked desire, and wept
As if her heart would break.

Day after day, night after night,
Laura kept watch in vain
In sullen silence of exceeding pain.
She never caught again the goblin cry:
"Come buy, come buy;" –
She never spied the goblin men
Hawking their fruits along the glen:
But when the noon waxed bright
Her hair grew thin and grey;
She dwindled, as the fair full moon doth turn
To swift decay and burn
Her fire away.

One day remembering her kernel-stone
She set it by a wall that faced the south;
Dewed it with tears, hoped for a root,

Watched for a waxing shoot,
But there came none;
It never saw the sun,
It never felt the trickling moisture run:
While with sunk eyes and faded mouth
She dreamed of melons, as a traveller sees
False waves in desert drouth
With shade of leaf-crowned trees,
And burns the thirstier in the sandful breeze.

She no more swept the house,
Tended the fowls or cows,
Fetched honey, kneaded cakes of wheat,
Brought water from the brook:
But sat down listless in the chimney-nook
And would not eat.

Tender Lizzie could not bear
To watch her sister's cankerous care
Yet not to share.
She night and morning
Caught the goblins' cry:
"Come buy our orchard fruits,
Come buy, come buy;" –
Beside the brook, along the glen,
She heard the tramp of goblin men,
The yoke and stir
Poor Laura could not hear;
Longed to buy fruit to comfort her,
But feared to pay too dear.

She thought of Jeanie in her grave,
Who should have been a bride;
But who for joys brides hope to have
Fell sick and died
In her gay prime,
In earliest Winter time
With the first glazing rime,
With the first snow-fall of crisp Winter time.

Till Laura dwindling
Seemed knocking at Death's door:
Then Lizzie weighed no more
Better and worse;
But put a silver penny in her purse,
Kissed Laura, crossed the heath with clumps of furze
At twilight, halted by the brook:
And for the first time in her life
Began to listen and look.

Laughed every goblin
When they spied her peeping:
Came towards her hobbling,
Flying, running, leaping,
Puffing and blowing,
Chuckling, clapping, crowing,
Clucking and gobbling,
Mopping and mowing,
Full of airs and graces,
Pulling wry faces,
Demure grimaces,

Cat-like and rat-like,
Ratel- and wombat-like,
Snail-paced in a hurry,
Parrot-voiced and whistler,
Helter skelter, hurry skurry,
Chattering like magpies,
Fluttering like pigeons,
Gliding like fishes, -
Hugged her and kissed her,
Squeezed and caressed her:
Stretched up their dishes,
Panniers, and plates:
"Look at our apples
Russet and dun,
Bob at our cherries,
Bite at our peaches,
Citrons and dates,
Grapes for the asking,
Pears red with basking
Out in the sun,
Plums on their twigs;
Pluck them and suck them,
Pomegranates, figs."-

"Good folk," said Lizzie,
Mindful of Jeanie:
"Give me much and many: -
Held out her apron,
Tossed them her penny.
"Nay, take a seat with us,

Honour and eat with us,"
They answered grinning:
"Our feast is but beginning.
Night yet is early,
Warm and dew-pearly,
Wakeful and starry:
Such fruits as these
No man can carry:
Half their bloom would fly,
Half their dew would dry,
Half their flavour would pass by.
Sit down and feast with us,
Be welcome guest with us,
Cheer you and rest with us." –
"Thank you," said Lizzie: "But one waits
At home alone for me:
So without further parleying,
If you will not sell me any
Of your fruits tho' much and many,
Give me back my silver penny
I tossed you for a fee."–
They began to scratch their pates,
No longer wagging, purring,
But visibly demurring,
Grunting and snarling.
One called her proud,
Cross-grained, uncivil;
Their tones waxed loud,
Their looks were evil.
Lashing their tails

They trod and hustled her,
Elbowed and jostled her,
Clawed with their nails,
Barking, mewing, hissing, mocking,
Tore her gown and soiled her stocking,
Twitched her hair out by the roots,
Stamped upon her tender feet,
Held her hands and squeezed their fruits
Against her mouth to make her eat.

White and golden Lizzie stood,
Like a lily in a flood, -
Like a rock of blue-veined stone
Lashed by tides obstreperously, -
Like a beacon left alone
In a hoary roaring sea,
Sending up a golden fire, -
Like a fruit-crowned orange-tree
White with blossoms honey-sweet
Sore beset by wasp and bee, -
Like a royal virgin town
Topped with gilded dome and spire
Close beleaguered by a fleet
Mad to tug her standard down.

One may lead a horse to water,
Twenty cannot make him drink.
Tho' the goblins cuffed and caught her,
Coaxed and fought her,
Bullied and besought her,

Scratched her, pinched her black as ink,
Kicked and knocked her,
Mauled and mocked her,
Lizzie uttered not a word;
Would not open lip from lip
Lest they should cram a mouthful in:
But laughed in heart to feel the drip
Of juice that syrupped all her face,
And lodged in dimples of her chin,
And streaked her neck which quaked like curd.
At last the evil people
Worn out by her resistance
Flung back her penny, kicked their fruit
Along whichever road they took,
Not leaving root or stone or shoot;
Some writhed into the ground,
Some dived into the brook
With ring and ripple,
Some scudded on the gale without a sound,
Some vanished in the distance.

In a smart, ache, tingle,
Lizzie went her way;
Knew not was it night or day;
Sprang up the bank, tore thro' the furze,
Threaded copse and dingle,
And heard her penny jingle
Bouncing in her purse,
Its bounce was music to her ear.
She ran and ran

As if she feared some goblin man
Dogged her with gibe or curse
Or something worse:
But not one goblin scurried after,
Nor was she picked by fear;
The kind heart made her windy-paced
That urged her home quite out of breath with haste
And inward laughter.

She cried, "Laura," up the garden,
"Did you miss me?
Come and kiss me.
Never mind my bruises,
Hug me, kiss me, suck my juices
Squeezed from goblin fruits for you,
Goblin pulp and goblin dew.
Eat me, drink me, love me;
Laura, make much of me:
For your sake I have braved the glen
And had to do with goblin merchant men."

Laura started from her chair,
Flung her arms up in the air,
Clutched her hair:
"Lizzie, Lizzie, have you tasted
For my sake the fruit forbidden?
Must your light like mine be hidden,
Your young life like mine be wasted,
Undone in mine undoing
And ruined in my ruin,

Thirsty, cankered, goblin-ridden?"—
She clung about her sister,
Kissed and kissed and kissed her:
Tears once again
Refreshed her shrunken eyes,
Dropping like rain
After long sultry drouth;
Shaking with aguish fear, and pain,
She kissed and kissed her with a hungry mouth.

Her lips began to scorch,
That juice was wormwood to her tongue,
She loathed the feast:
Writhing as one possessed she leaped and sung,
Rent all her robe, and wrung
Her hands in lamentable haste,
And beat her breast.
Her locks streamed like the torch
Borne by a racer at full speed,
Or like the mane of horses in their flight,
Or like an eagle when she stems the light
Straight toward the sun,
Or like a caged thing freed,
Or like a flying flag when armies run.

Swift fire spread thro' her veins, knocked at her heart,
Met the fire smouldering there
And overbore its lesser flame;
She gorged on bitterness without a name:
Ah! fool, to choose such part

Of soul-consuming care!
Sense failed in the mortal strife:
Like the watch-tower of a town
Which an earthquake shatters down,
Like a lightning-stricken mast,
Like a wind-uprooted tree
Spun about,
Like a foam-topped waterspout
Cast down headlong in the sea,
She fell at last;
Pleasure past and anguish past,
Is it death or is it life?

Life out of death.
That night long Lizzie watched by her,
Counted her pulse's flagging stir,
Felt for her breath,
Held water to her lips, and cooled her face
With tears and fanning leaves:
But when the first birds chirped about their eaves,
And early reapers plodded to the place
Of golden sheaves,
And dew-wet grass
Bowed in the morning winds so brisk to pass,
And new buds with new day
Opened of cup-like lilies on the stream,
Laura awoke as from a dream,
Laughed in the innocent old way,
Hugged Lizzie but not twice or thrice;
Her gleaming locks showed not one thread of grey,

Her breath was sweet as May
And light danced in her eyes.

Days, weeks, months, years
Afterwards, when both were wives
With children of their own;
Their mother-hearts beset with fears,
Their lives bound up in tender lives;
Laura would call the little ones
And tell them of her early prime,
Those pleasant days long gone
Of not-returning time:
Would talk about the haunted glen,
The wicked, quaint fruit-merchant men,
Their fruits like honey to the throat
But poison in the blood;
(Men sell not such in any town :)
Would tell them how her sister stood
In deadly peril to do her good,
And win the fiery antidote:
Then joining hands to little hands
Would bid them cling together,
"For there is no friend like a sister
In calm or stormy weather;
To cheer one on the tedious way,
To fetch one if one goes astray,
To lift one if one totters down,
To strengthen whilst one stands."

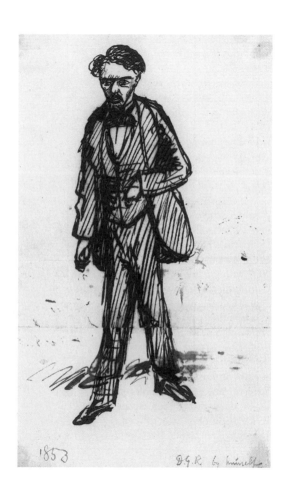

1853

D.G.R. by Munro

Dante Gabriel Rossetti

Genius in Beauty

Beauty like hers is genius. Not the call
 Of Homer's or of Dante's heart sublime, –
 Not Michael's hand furrowing the zones of time, –
Is more with compassed mysteries musical;
Nay, not in Spring's or Summer's sweet footfall
 More gathered gifts exuberant Life bequeaths
 Than doth this sovereign face, whose
 love-spell breathes
Even from its shadowed contour on the wall.

As many men are poets in their youth,
 But for one sweet-strung soul the wires prolong
 Even through all change the indomitable song;
So in likewise the envenomed years, whose tooth
Rends shallower grace with ruin void of truth,
 Upon this beauty's power shall wreak no wrong.

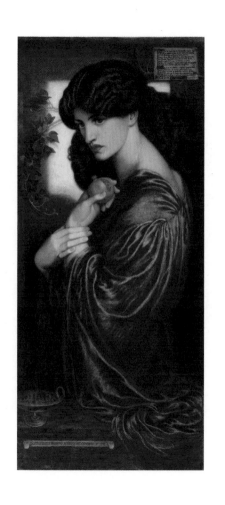

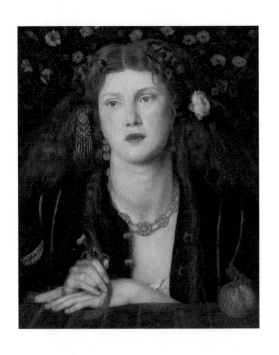

Jenny

Lazy laughing languid Jenny,
Fond of a kiss and fond of a guinea,
Whose head upon my knee to-night
Rests for a while, as if grown light
With all our dances and the sound
To which the wild tunes spun you round:
Fair Jenny mine, the thoughtless queen
Of kisses which the blush between
Could hardly make much daintier;
Whose eyes are as blue skies, whose hair
Is countless gold incomparable:
Fresh flower, scarce touched with signs that tell
Of Love's exuberant hotbed: – Nay,
Poor flower left torn since yesterday
Until to-morrow leave you bare;
Poor handful of bright spring-water
Flung in the whirlpool's shrieking face;
Poor shameful Jenny, full of grace
Thus with your head upon my knee; –
Whose person or whose purse may be
The lodestar of your reverie?

 This room of yours, my Jenny, looks
A change from mine so full of books,
Whose serried ranks hold fast, forsooth,

So many captive hours of youth, –
The hours they thieve from day and night
To make one's cherished work come right,
And leave it wrong for all their theft,
Even as to-night my work has left:
Until I vowed that since my brain
And eyes of dancing seemed so fain,
My feet should have some dancing too: –
And thus it was I met with you.
Well, I suppose 'twas hard to part,
For here I am. And now, sweetheart,
You seem too tired to get to bed.

 It was a careless life I led
When rooms like this were scarce so strange
Not long ago. What breeds the change, –
The many aims or the few years?
Because to-night it all appears
Something I do not know again.

 The cloud's not danced out of my brain, –
The cloud that made it turn and swim
While hour by hour the books grew dim.
Why, Jenny, as I watch you there, –
For all your wealth of loosened hair,
Your silk ungirdled and unlaced
And warm sweets open to the waist,
All golden in the lamplight's gleam, –
You know not what a book you seem,
Half-read by lightning in a dream!

How should you know, my Jenny? Nay,
And I should be ashamed to say: -
Poor beauty, so well worth a kiss!
But while my thought runs on like this
With wasteful whims more than enough,
I wonder what you're thinking of.

 If of myself you think at all,
What is the thought? - conjectural
On sorry matters best unsolved? -
Or inly is each grace revolved
To fit me with a lure? - or (sad
To think!) perhaps you're merely glad
That I'm not drunk or ruffianly
And let you rest upon my knee.

 For sometimes, were the truth confessed,
You're thankful for a little rest, -
Glad from the crush to rest within,
From the heart-sickness and the din
Where envy's voice at virtue's pitch
Mocks you because your gown is rich;
And from the pale girl's dumb rebuke,
Whose ill-clad grace and toil-worn look
Proclaim the strength that keeps her weak,
And other nights than yours bespeak;
And from the wise unchildish elf,
To schoolmate lesser than himself
Pointing you out, what thing you are: -
Yes, from the daily jeer and jar,

From shame and shame's outbraving too,
Is rest not sometimes sweet to you? –
But most from the hatefulness of man
Who spares not to end what he began,
Whose acts are ill and his speech ill,
Who, having used you at his will,
Thrusts you aside, as when I dine
I serve the dishes and the wine.

Well, handsome Jenny mine, sit up:
I've filled our glasses, let us sup,
And do not let me think of you,
Lest shame of yours suffice for two.
What, still so tired? Well, well then, keep
Your head there, so you do not sleep;
But that the weariness may pass
And leave you merry, take this glass.
Ah! lazy lily hand, more blessed
If ne'er in rings it had been dressed
Nor ever by a glove concealed!

Behold the lilies of the field,
They toil not neither do they spin;
(So doth the ancient text begin, –
Not of such rest as one of these
Can share.) Another rest and ease.
Along each summer-sated path
From its new lord the garden hath,
Than that whose spring in blessings ran
Which praised the bounteous husbandman,

Ere yet, in days of hankering breath,
The lilies sickened unto death.

What, Jenny, are your lilies dead?
Aye, and the snow-white leaves are spread
Like winter on the garden-bed.
But you had roses left in May, -
They were not gone too. Jenny, nay,
But must your roses die, and those
Their purfled buds that should unclose?
Even so; the leaves are curled apart,
Still red as from the broken heart,
And here's the naked stem of thorns.

Nay, nay mere words. Here nothing warns
As yet of winter. Sickness here
Or want alone could waken fear, -
Nothing but passion wrings a tear.
Except when there may rise unsought
Haply at times a passing thought
Of the old days which seem to be
Much older than any history
That is written in any book;
When she would lie in fields and look
Along the ground through the blown grass,
And wonder where the city was,
Far out of sight, whose broil and bale
They told her then for a child's tale.

Jenny, you know the city now,
A child can tell the tale there, how
Some things which are not yet enrolled
In market-lists are bought and sold
Even till the early Sunday light,
When Saturday night is market-night
Everywhere, be it dry or wet,
And market-night in the Haymarket.
Our learned London children know,
Poor Jenny, all your pride and woe;
Have seen your lifted silken skirt
Advertise dainties through the dirt;
Have seen your coach-wheels splash rebuke
On virtue; and have learned your look
When, wealth and health slipped past, you stare
Along the streets alone, and there,
Round the long park, across the bridge,
The cold lamps at the pavement's edge
Wind on together and apart,
A fiery serpent for your heart.

Let the thoughts pass, an empty cloud!
Suppose I were to think aloud, –
What if to her all this were said?
Why, as a volume seldom read
Being opened halfway shuts again,
So might the pages of her brain
Be parted at such words, and thence
Close back upon the dusty sense.
For is there hue or shape defined

In Jenny's desecrated mind,
Where all contagious currents meet,
A Lethe of the middle street?
Nay, it reflects not any face,
Nor sound is in its sluggish pace,
But as they coil those eddies clot,
And night and day remembers not.

Why, Jenny, you're asleep at last! –
Asleep, poor Jenny, hard and fast, –
So young and soft and tired; so fair,
With chin thus nestled in your hair,
Mouth quiet, eyelids almost blue
As if some sky of dreams shone through!

Just as another woman sleeps!
Enough to throw one's thoughts in heaps
Of doubt and horror, – what to say
Or think, – this awful secret sway,
The potter's power over the clay!
Of the same lump (it has been said)
For honour and dishonour made,
Two sister vessels. Here is one.

My cousin Nell is fond of fun,
And fond of dress, and change, and praise,
So mere a woman in her ways:
And if her sweet eyes rich in youth
Are like her lips that tell the truth,
My cousin Nell is fond of love.

And she's the girl I'm proudest of.
Who does not prize her, guard her well?
The love of change, in cousin Nell,
Shall find the best and hold it dear:
The unconquered mirth turn quieter
Not through her own, through others' woe:
The conscious pride of beauty glow
Beside another's pride in her,
One little part of all they share.
For Love himself shall ripen these
In a kind of soil to just increase
Through years of fertilizing peace.

Of the same lump (as it is said)
For honour and dishonour made,
Two sister vessels. Here is one.

It makes a goblin of the sun.

So pure, – so fallen! How dare to think
Of the first common kindred link?
Yet, Jenny, till the world shall burn
It seems that all things take their turn;
And who shall say but this fair tree
May need, in changes that may be,
Your children's children's charity?
Scorned then, no doubt, as you are scorned!
Shall no man hold his pride forewarned
Till in the end, the Day of Days,
At Judgement, one of his own race,

As frail and lost as you, shall rise, –
His daughter, with his mother's eyes?

How Jenny's clock ticks on the shelf!
Might not the dial scorn itself
That has such hours to register?
Yet as to me, even so to her
Are golden sun and silver moon,
In daily largesse of earth's boon,
Counted for life-coins to one tune.
And if, as blindfold fates are tossed,
Through some one man this life be lost,
Shall soul not somehow pray for soul?

Fair shines the gilded aureole
In which our highest painters place
Some living woman's simple face.
And the stilled features thus descried
As Jenny's long throat droops aside, –
The shadows where the cheeks are thin,
And pure wide curve from ear to chin, –
With Raffael's, Leonardo's hand
To show them to men's souls, might stand,
Whole ages long, the whole world through,
For preachings of what God can do.
What has man done here? How atone,
Great God, for this which man has done?
And for the body and soul which by
Man's pitiless doom must now comply
With lifelong hell, what lullaby

Of sweet forgetful second birth
Remains? All dark. No sign on earth
What measure of God's rest endows
The many mansions of his house.

If but a woman's heart might see
Such erring heart unerringly
For once! But that can never be.

Like a rose shut in a book
In which pure women may not look,
For its base pages claim control
To crush the flower within the soul;
Where through each dead rose-leaf that clings,
Pale as transparent psyche-wings,
To the vile text, are traced such things
As might make lady's cheek indeed
More than a living rose to read;
So nought save foolish foulness may
Watch with hard eyes the sure decay;
And so the life-blood of this rose,
Puddled with shameful knowledge, flows
Through leaves no chaste hand may unclose:
Yet still it keeps such faded show
Of when 'twas gathered long ago,
That the crushed petals' lovely grain,
The sweetness of the sanguine stain,
Seen of a woman's eyes, must make
Her pitiful heart, so prone to ache,
Love roses better for its sake: –

Only that this can never be: –
Even so unto her sex is she.

Yet, Jenny, looking long at you,
The woman almost fades from view.
A cipher of man's changeless sum
Of lust, past, present, and to come,
Is left. A riddle that one shrinks
To challenge from the scornful sphinx.

Like a toad within a stone
Seated while Time crumbles on;
Which sits there since the earth was cursed
For Man's transgression at the first;
Which, living through all centuries,
Not once has seen the sun arise;
Whose life, to its cold circle charmed,
The earth's whole summers have not warmed;
Which always – whitherso the stone
Be flung – sits there, deaf, blind, alone; –
Aye, and shall not be driven out
Till that which shuts him round about
Break at the very Master's stroke,
And the dust thereof vanish as smoke,
And the seed of Man vanish as dust: –
Even so within this world is Lust.

Come, come, what use in thoughts like this?
Poor little Jenny, good to kiss, –
You'd not believe by what strange roads

Thought travels, when your beauty goads
A man to-night to think of toads!
Jenny, wake up. . . . Why, there's the dawn!

And there's an early waggon drawn
To market, and some sheep that jog
Bleating before a barking dog;
And the old streets come peering through
Another night that London knew;
And all as ghostlike as the lamps.

So on the wings of day decamps
My last night's frolic. Glooms begin
To shiver off as lights creep in
Past the gauze curtains half drawn-to,
And the lamp's doubled shade grows blue, –
Your lamp, my Jenny, kept alight,
Like a wise virgin's, all one night!
And in the alcove coolly spread
Glimmers with dawn your empty bed;
And yonder your fair face I see
Reflected lying on my knee,
Where teems with first foreshadowings
Your pier-glass scrawled with diamond rings:
And on your bosom all night worn
Yesterday's rose now droops forlorn,
But dies not yet this summer morn.

And now without, as if some word
Had called upon them that they heard,

The London sparrows far and nigh
Clamour together suddenly;
And Jenny's cage-bird grown awake
Here in their song his part must take,
Because here too the day doth break.

And somehow in myself the dawn
Among stirred clouds and veils withdrawn
Strikes greyly on her. Let her sleep.
But will it wake her if I heap
These cushions thus beneath her head
Where my knee was? No, – there's your bed,
My Jenny, while you dream. And there
I lay among your golden hair
Perhaps the subject of your dreams,
These golden coins.

For still one deems
That Jenny's flattering sleep confers
New magic on the magic purse, –
Grim web, how clogged with shrivelled flies!
Between the threads fine fumes arise
And shape their pictures in the brain.
There roll no streets in glare and rain,
Nor flagrant man-swine whets his tusk;
But delicately sighs in musk
The homage of the dim boudoir;
Or like a palpitating star
Thrilled into song, the opera-night
Breathes faint in the quick pulse of light;

Or at the carriage-window shine
Rich wares for choice; or, free to dine,
Whirls through its hour of health (divine
For her) the concourse of the Park.
And though in the discounted dark
Her functions there and here are one,
Beneath the lamps and in the sun
There reigns at least the acknowledged belle
Apparelled beyond parallel.
Ah Jenny, yes, we know your dreams.

For even the Paphian Venus seems,
A goddess o'er the realms of love,
When silver-shrined in shadowy grove:
Aye, or let offerings nicely placed
But hide Priapus to the waist,
And whoso looks on him shall see
An eligible deity.

Why, Jenny, waking here alone
May help you to remember one,
Though all the memory's long outworn
Of many a double-pillowed morn.
I think I see you when you wake,
And rub your eyes for me, and shake
My gold, in rising, from your hair,
A Danaë for a moment there.

Jenny, my love rang true! for still
Love at first sight is vague, until
That tinkling makes him audible.

And must I mock you to the last,
Ashamed of my own shame, - aghast
Because some thoughts not born amiss
Rose at a poor fair face like this?
Well, of such thoughts so much I know:
In my life, as in hers, they show,
By a far gleam which I may near,
A dark path I can strive to clear.

Only one kiss. Good-bye, my dear.

Nuptial Sleep

At length their long kiss severed, with sweet smart:
And as the last slow sudden drops are shed
From sparkling eaves when all the storm has fled,
So singly flagged the pulses of each heart.
Their bosoms sundered, with the opening start
Of married flowers to either side outspread
From the knit stem; yet still their mouths,
 burnt red,
Fawned on each other where they lay apart.

Sleep sank them lower than the tide of dreams,
And their dreams watched them sink, and
 slid away.
Slowly their souls swam up again, through gleams
Of watered light and dull drowned waifs of day;
Till from some wonder of new woods and streams
He woke, and wondered more: for there she lay.

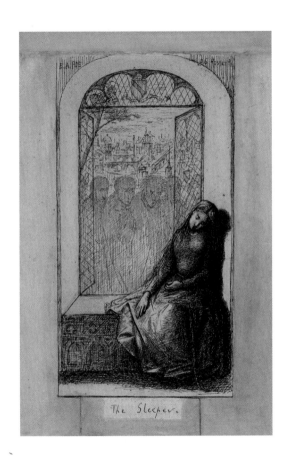

The Sleeper.

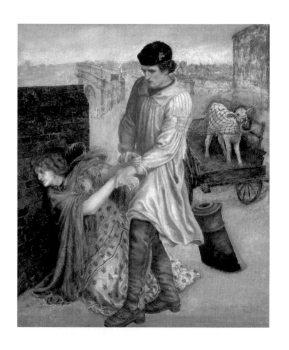

Found

"THERE is a budding morrow in midnight:"—
So sang our Keats, our English nightingale.
And here, as lamps across the bridge turn pale
In London's smokeless resurrection-light,
Dark breaks to dawn. But o'er the deadly blight
Of Love deflowered and sorrow of none avail,
Which makes this man gasp and this woman quail,
Can day from darkness ever again take flight?
Ah! gave not these two hearts their mutual pledge,
Under one mantle sheltered 'neath the hedge
In gloaming courtship? And, O God! to-day
He only knows he holds her;—but what part
Can life now take? She cries in her locked heart,—
"Leave me—I do not know you—go away!"

The Kiss

What smouldering senses in death's sick delay
 Or seizure of malign vicissitude
 Can rob this body of honour, or denude
This soul of wedding-raiment worn to-day?
For lo! even now my lady's lips did play
 With these my lips such consonant interlude
 As laurelled Orpheus longed for when he wooed
The half-drawn hungering face with that last lay.

I was a child beneath her touch, – a man
 When breast to breast we clung, even I and she, –
 A spirit when her spirit looked through me, –
A god when all our life-breath met to fan
Our life-blood, till love's emulous ardours ran,
 Fire within fire, desire in deity.

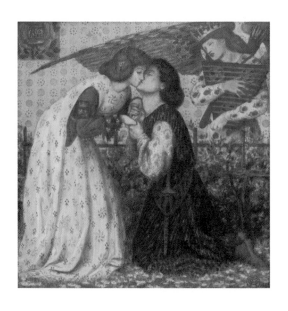

The Portrait

This is her picture as she was:
 It seems a thing to wonder on,
As though mine image in the glass
 Should tarry when myself am gone.
I gaze until she seems to stir, –
Until mine eyes almost aver
 That now, even now, the sweet lips part
 To breathe the words of the sweet heart: –
And yet the earth is over her.

Alas! even such the thin-drawn ray
 That makes the prison-depths more rude, –
The drip of water night and day
 Giving a tongue to solitude.
Yet only this, of love's whole prize,
Remains; save what in mournful guise
 Takes counsel with my soul alone, –
 Save what is secret and unknown,
Below the earth, above the skies.

In painting her I shrined her face
 Mid mystic trees, where light falls in
Hardly at all; a covert place
 Where you might think to find a din
Of doubtful talk, and a live flame
Wandering, and many a shape whose name
 Not itself knoweth, and old dew,
 And your own footsteps meeting you,
And all things going as they came.

A deep dim wood; and there she stands
 As in that wood that day: for so
Was the still movement of her hands
 And such the pure line's gracious flow.
And passing fair the type must seem,
Unknown the presence and the dream.
 'Tis she: though of herself, alas!
 Less than her shadow on the grass
Or than her image in the stream.

That day we met there, I and she
 One with the other all alone;
And we were blithe; yet memory
 Saddens those hours, as when the moon
Looks upon daylight. And with her
I stooped to drink the spring-water,
 Athirst where other waters sprang;
 And where the echo is, she sang, –
My soul another echo there.

But when that hour my soul won strength
 For words whose silence wastes and kills,
Dull raindrops smote us, and at length
 Thundered the heat within the hills.
That eve I spoke those words again
Beside the pelted window-pane;
 And there she hearkened what I said,
 With under-glances that surveyed
The empty pastures blind with rain.

Next day the memories of these things,
 Like leaves through which a bird has flown,
Still vibrated with Love's warm wings;
 Till I must make them all my own
And paint this picture. So, 'twixt ease
Of talk and sweet long silences,
 She stood among the plants in bloom
 At windows of a summer room,
To feign the shadow of the trees.

And as I wrought, while all above
 And all around was fragrant air,
In the sick burthen of my love
 It seemed each sun-thrilled blossom there
Beat like a heart among the leaves.
O heart that never beats nor heaves,
 In that one darkness lying still,
 What now to thee my love's great will
Or the fine web the sunshine weaves?

For now doth daylight disavow
 Those days, - nought left to see or hear.
Only in solemn whispers now
 At night-time these things reach mine ear;
When the leaf-shadows at a breath
Shrink in the road, and all the heath,
 Forest and water, far and wide,
 In limpid starlight glorified,
Lie like the mystery of death.

Last night at last I could have slept,
 And yet delayed my sleep till dawn,
Still wandering. Then it was I wept:
 For unawares I came upon
Those glades where once she walked with me:
And as I stood there suddenly,
 All wan with traversing the night,
 Upon the desolate verge of light
Yearned loud the iron-bosomed sea.

Even so, where Heaven holds breath and hears
 The beating heart of Love's own breast, –
Where round the secret of all spheres
 All angels lay their wings to rest, –
How shall my soul stand rapt and awed,
When, by the new birth borne abroad
 Throughout the music of the suns,
 It enters in her soul at once
And knows the silence there for God!

Here with her face doth memory sit
 Meanwhile, and wait the day's decline,
Till other eyes shall look from it,
 Eyes of the spirit's Palestine,
Even than the old gaze tenderer:
While hopes and aims long lost with her
 Stand round her image side by side,
 Like tombs of pilgrims that have died
About the Holy Sepulchre.

First published 2023 by order of the
Tate Trustees by Tate Publishing,
a division of Tate Enterprises Ltd,
Millbank, London SW1P 4RG
www.tate.org.uk/publishing

A catalogue record for this book is available
from the British Library
ISBN 978 1 84976 843 6

Distributed in the United States and Canada
by ABRAMS, New York

Library of Congress Control Number applied for

Cover: Christina Rossetti, *Goblin Market* 1865 (second edition),
book, 22.9 × 15.2 (frontispiece)

Measurements of artworks are given in centimetres, height before
width, before depth

Senior Editor: Alice Chasey
Production: Bill Jones
Picture Researcher: Emma O'Neill
Designed by Lorenz Klingebiel
Typeface: Albis by Jack Niblett
Colour reproduction by DL Imaging, London
Printed and bound in Italy by Graphicom